1-

MW01042013

Arthur Baker

celtic hand

STROKE BY STROKE

(Irish Half-Uncial from "The Book of Kells")

An Arthur Baker Calligraphy Manual
With an Introduction by William Hogarth

Dover Publications, Inc., New York

Introduction copyright © 1983 by William Hogarth.
All other contents copyright © 1983 by Arthur Baker.
All rights reserved under Pan American and International Copyright Conventions.

Published in Canada by General Publishing Company, Ltd., 30 Lesmill Road, Don Mills, Toronto, Ontario.
Published in the United Kingdom by Constable and Company, Ltd.

Celtic Hand Stroke by Stroke (Irish Half-Uncial from "The Book of Kells"): An Arthur Baker Calligraphy Manual is
a new work, first published by Dover Publications, Inc., in 1983.

Manufactured in the United States of America
Dover Publications, Inc., 180 Varick Street, New York, N.Y. 10014

Library of Congress Cataloging in Publication Data

Baker, Arthur.
 Celtic hand stroke by stroke.

 (Dover pictorial archive series)
 1. Calligraphy, Celtic. 2. Bible. N.T. Gospels. Latin. Book of Kells. I. Title. II. Series.
NK3610.B34 1982 745.6'197 82-9622
ISBN 0-486-24336-2 (pbk.)

"Found in an Irish Bog"

In the lovely green center of Dublin stand the buildings of Trinity College, and in the Long Room of Trinity's elegant eighteenth-century library is a case containing the Book of Kells. The remaining leaves, rebound many times, are currently in four volumes. One at a time, the books are displayed spread open, and a page is turned daily; thus, a visitor could see the entire text in half-a-year or so. James Joyce came to look, and in *Finnegans Wake* talks about "those long-legged M's" of the manuscript. The Kells manuscript is one of the few surviving examples of insular writing, and a magnificent one.

There is a great deal of uncertainty about the origins of many of these British Isles (hence "insular") manuscripts of the early middle ages. The Kells Gospel Book, for such it is, is thought to have been written out and decorated in the late eighth century, possibly on the sacred island of Iona (founded by Saint Columba in 563) off the coast of Scotland, or in a monastery in Northumbria in northern England. The book appeared at Kells in 804, brought by Irish monks fleeing the Viking raiders who were devastating coastal towns and terrorizing much of Europe. These Norsemen included the Normans who invaded France and in 1066 conquered England when Duke William defeated King Harold at Hastings.

At about the time of the Norman Conquest, a note appeared in the records of the chapter house at Kells that the great Gospel Book of Kells was stolen for its gold- and jewel-encrusted cover. The pages, torn out, were found some months later in a bog.

Beyond the intricate decoration and illustration — the "carpet" pages of the Kells manuscript — the running text shows a great deal of familiarity with letter forms deriving from the Roman capitals and the quadrata, or written Roman hand, through the uncials and half-uncials of the anything-but "dark ages" of popular thought. Other influences include Middle Eastern and Egyptian. There was an enormous amount of travel between religious centers as Christianity spread throughout western Europe. The strong Irish monasteries had influential subsidiary outposts in Europe, and travelers brought samples of exotic work back to the "insular" communities. At about the time the Book of Kells was created, Charlemagne became Holy Roman Emperor and called for handwriting reform. A scholar from northern England, Bishop Alcuin of York, organized for Charlemagne this unification of style still known to us as the Carolingian, or Caroline minuscule — close ancestor of the best "Roman" printing types, founded by Venetian printers in the late fifteenth century.

The word *uncial* is ambiguous. Derived from the Latin word for one-twelfth of a *pes* (the Roman foot), it was thought for many years to be a reference to letters one inch in height — but no uncial manuscripts with letters of that size have ever been discovered. An alternate meaning, "bit by bit," is perhaps more acceptable, considering the gradual development of the letter form from the Roman scripts. For several centuries, as the monastic clerks created scripts in western European communities, one form existed for each letter of the alphabet. Distinctions, our capitalization, originated with the occasional use of the Roman capital, or an ornately decorated letter. Often the scribe and the artist were one, though scholars have determined that at least three different scribes worked on the Kells Gospel manuscript, and the same number of artists decorated the pages. Legibility was a constant problem, and a way of making the letters consistently recognizable was not finally resolved until printing type produced the ultimate consistency. Viking raids and the abandonment and destruction of monasteries and their *scriptoria* are primary reasons for the paucity of surviving manuscripts. The noted examples: Kells, the Books of Durrow and Armagh, the Gospels of Lindisfarne, Durham, Echternach and Lichfield are all related in time and place as insular uncial manuscripts. Missing are those which may have rivaled the survivors in beauty, and most of the models from which the monks worked — the far travelers from the east, the oriental and Roman.

In the most recent facsimile publication (Alfred A. Knopf, 1974), the scholar Françoise Henry says of the

Kells Gospel and other insular writing: "The Irish script was elaborated in Ireland during the sixth and seventh centuries from various scripts of Roman books brought by missionaries into Ireland from the time of its conversion to Christianity in the fifth century." The stress on Roman brings us once again to the singular contribution of Arthur Baker to this present modernization of the Kells hand.

As the discoverer of the pen-turning system that gave the Roman capitals their enduring beauty, Baker shows here the pen manipulation that the Irish monks also practiced. Close study of the Irish uncials in the Kells manuscript has shown that the distinctive triangular serif was created with a pivoting motion in one stroke, not added as an extra fillip. This unique feature is clearly seen in this second of his revolutionary "stroke by stroke" manuals (the first was his *Chancery Cursive*). When it can be seen how the fingers and pen create each stroke of each letter, the manipulation is conveyed quickly and clearly.

Included in the wrongheaded notions of the calligraphic revivalists in England at the turn of the present century was their lack of appreciation for the Kells manuscript's sophisticated execution. Like the Roman capitals, the Kells letters are written with a quill manipulation pattern based on economy of movement. It has remained for Arthur Baker to show us this feature, demonstrating that the Irish scribes were familiar with calligraphic traditions in use all over the monastic world at the time. Proof lies in the work of the illuminators and artists whose complex trefoil decoration, fantastic animal forms and elongated initials show knowledge of Hebrew, Islamic and Byzantine design patterns. But the primary influence is still that of the classic Roman capitals, with an integrity of shape and construction that lies behind all later development of historic letter forms created by quill, reed or brush.

As a key to Kells letters, look at the triangular form at the top of many Kells letter forms. Until now its derivation was a mystery, but revelations about Roman capitals made by Baker solve the problem. The script had to be logical and consistent, and to add on the triangles after the vertical stroke was made would have defied directness and economy. A close look at the original manuscript shows the letters tapering outward under the triangle; this gives us a clue on how to form the tops of letters. The pen rotates, fixed at the upper right, then descends at an angle and flattens and widens as it approaches the bottom of the stem. All clear and logical: compare the Roman I shown in the figure with its Irish equivalent. The round forms are also, like the Roman, manipulated— proving again that the idea of rigid, fixed-pen calligraphy is wholly illogical, and is an affront to the

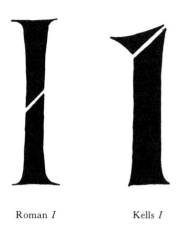

Roman *I* Kells *I*

sense and sensibility of our predecessor scribes. The discrepancies in width in some letters is explained by the tool: a quill responds to pressure more than the metal Coit pen with which the forms in the figure were executed.

Baker has somewhat modernized and Romanized the original letters of the Irish uncial alphabet and added a *j, k, v, w* and *y* written in the Kells spirit. Alternates for the distinctive Celtic *a, d* and *n* have been added to the stroke-by-stroke section for calligraphers who find the Celtic forms of these letters difficult to recognize. The Celtic *g* is a unique uncial letter, but the Celtic *q* can easily be mistaken for the modern *g*. The decorative, embellished letters appearing on pages 12–17 are all authentic Celtic designs.

Pen manipulation is not quickly learned, but like all worthwhile achievements takes practice and attention. Before this concept of a stroke-by-stroke manual, it would have been impossible to accomplish without direct observation of the pen-turning technique. A suggested list of materials following the introduction makes this manual even more valuable. The conscientious calligrapher can learn much from the techniques and procedures shown here—perhaps more than from any previously published instruction guide. It really is the next best thing to sitting at Baker's side. For the first time, a logical explication of the specialized uncial letter form is here. Read the instructions, follow the examples and see the ideas fall into place under your own fingers. Once again, Arthur Baker has shown with brilliant penmanship and stroke-by-stroke guidance how to escape from the sterile, academic dullness present in many of the modern calligraphic teaching practices. We no longer need, metaphorically, to lie in an Irish bog, as did the Kells pages themselves a thousand years ago, but can see the long heritage stretching back two thousand years to the Roman progenitor—the magnificent first-century capital letters.

WILLIAM HOGARTH

Instructions

PENS

The best pen to learn with is a Coit pen with a ¼"
to ½" nib (see Figure 1). It has a good ink flow and
makes letters that are large enough to be clearly seen
and analyzed. The point and holder are a single unit.
The Speedball point size C-0 (see Figure 2) or Brause
5 mm (see Figure 3) are also acceptable, but these will
need a pen holder. The store that sells the pen points
(nibs) will probably have a variety of holders to select
from.

Figure 1. The Coit pen, ½".

Figure 2. Speedball C-O nib in a holder.

Figure 3. Brause 5 mm nib in a holder.

Left-handers can obtain left-oblique pen points, or
grind right-handed points to a flat edge on an Arkan-
sas stone. Because it is flat-edged, the Coit pen can
be used ambidextrously.

Dried waterproof inks can be cleaned off pens easily
by soaking them in ammonia.

If you cannot find Coit pens in your art supply
store, they can be ordered from:

Coit Calligraphics, Inc.
Department ABC
Old Mill Road
Georgetown, CT 06829
(203) 544-9140

INK

Any black ink, preferably waterproof, will work.
Pelikan Black Drawing Ink, Higgins Engrossing Ink
or Grumbacher India Ink are all satisfactory.

WORK SURFACE, PAPER AND LINES

Calligraphy should be done on an inclined work sur-
face. If you do not have a drawing table, an easy
substitute is to prop a board on a table with some
books under the back edge. The slant can be easily
altered by adding or removing books. To keep the
lower edge of the board from slipping off the table,
a thin strip of wood can be taped to the table edge
with masking tape (see Figure 4).

Inexpensive tracing paper, as large as is comfort-
able for you to work on, is good for practice. Layout
bond or white drawing paper is also fine and comes
in 50- and 100-sheet pads. So-called "calligraphy
paper" is often far too expensive for practice; it should
only be used for finished projects.

Figure 4. Work surface.

Figure 5. Sample guidelines.

The best way to practice is to draw lines in ink on
a sheet of paper, then lay a sheet of paper over the
lined page and write the letters, tracing the guide lines
(see Figure 5). In this way the guidelines need only

be drawn once. Vertical guidelines may be helpful at first. It is a good idea to pad the work surface with several sheets of paper securely taped down. Over them you can tape the guide sheet, and then lightly tape the work sheet on top so that it can be removed easily.

HOLDING THE PEN

Hold the pen comfortably, like a pencil, with your hand as relaxed as possible (see Figure 6). The movements of the hand, wrist and fingers in turning the pen are unified, simultaneous and natural, as the instruction plates show. The turning of the pen is controlled mostly by the positioning of the hand, and to a lesser extent by the thumb and index finger. The movement is gradual, with the pen changing position in the hand, as the sequential drawings show. Let your arm move freely to provide direction for the stroke.

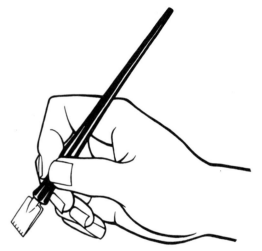

Figure 6. Correct way to hold the pen (side view).

THE LETTERS

The basic measure of the height of letters is the height of the minuscule or lower case *x*, which is called the x-height (see Figure 7). The x-height of the Celtic half-uncial is equal to 4½ to 5 pen widths. The length of the ascenders and descenders in this alphabet is approximately two pen widths.

The triangular form at the top of the letters is illustrated here (see Figure 8). Starting from position 1, the pen is turned approximately 45° counterclockwise while being pulled slightly to the right. When the pen is at position 3, the stroke proceeds down vertically, the pen gradually being turned back to its original angle. Practice this motion until it feels routine.

The letter *l* and the vertical strokes in letters like *f, h, k* and *m* should be drawn at a 90° angle to the baseline.

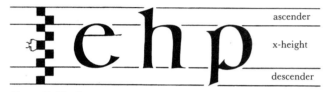

Figure 7. The letters.

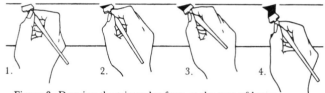

Figure 8. Drawing the triangular form at the tops of letters.

SPACING

Spaces between letters within a word should be consistent; that is, each letter should be centered in the space between its neighbors. To keep letter spaces constant as you continue writing, check back every few words to the first words you wrote, comparing the effects and adjusting if necessary. Try to envision a whole word before writing it to anticipate where spacing might be a problem. The spaces between words should be about the width of the letter *o*.

the quick
brown fox
jumps over
the-lazy
dog

abcd
ijklm
rstu
xy

efgh
nopq
vwx
z

A α œ α

o d e

r f ʒ

r s s

s s s

r r z

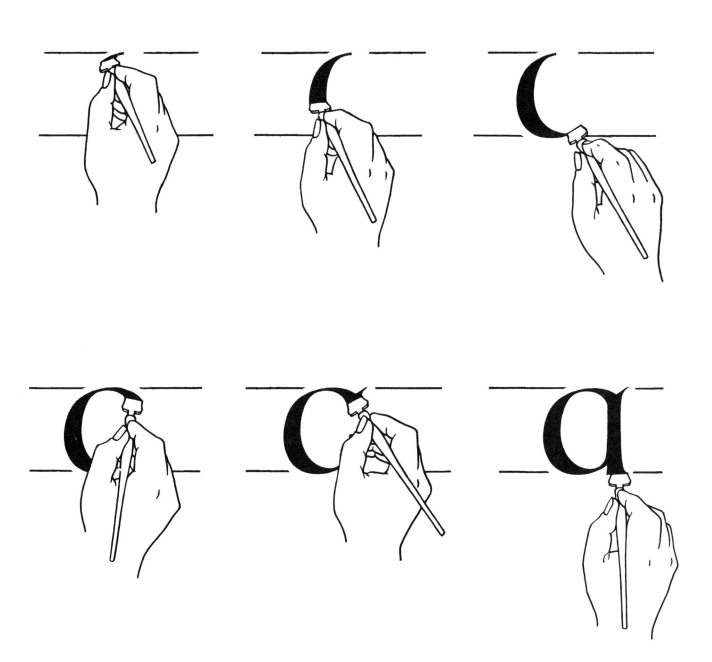

Alternate form of letter *a*.

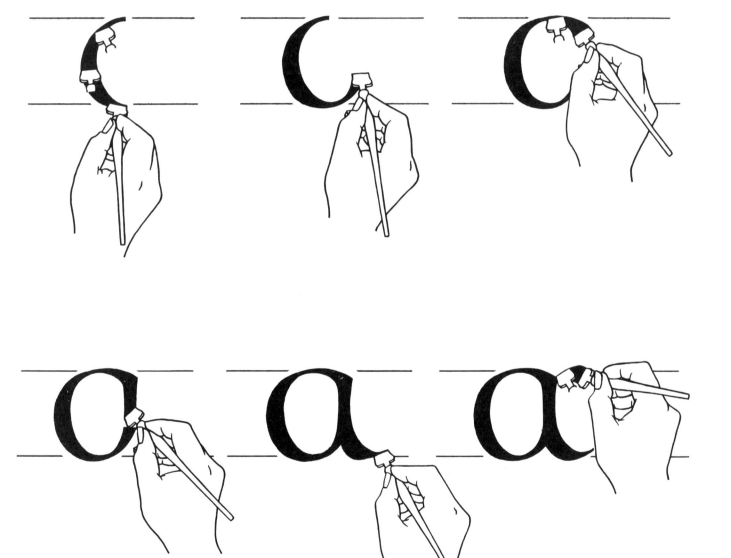

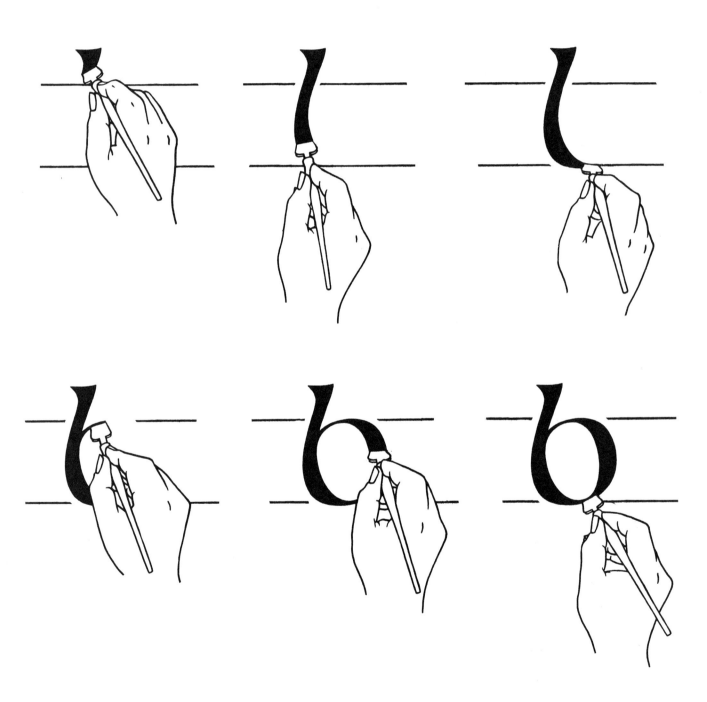

C

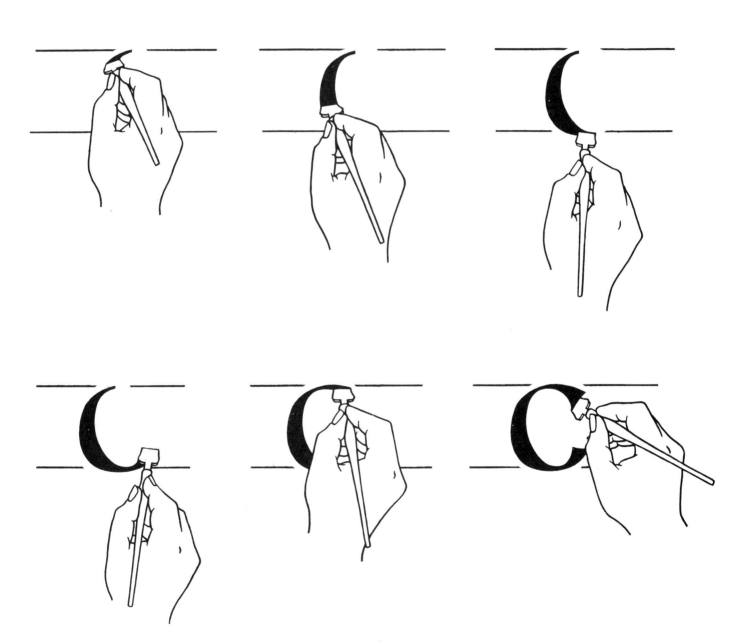

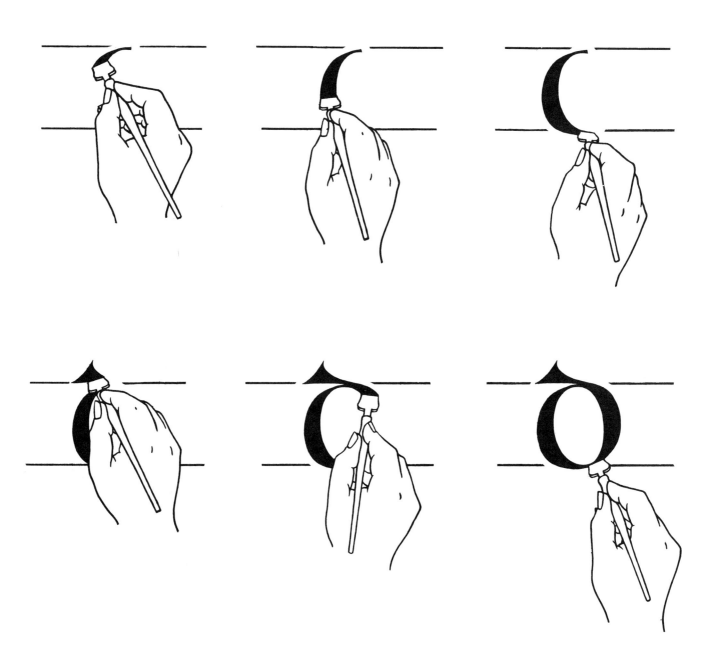

Alternate form of letter *d*.

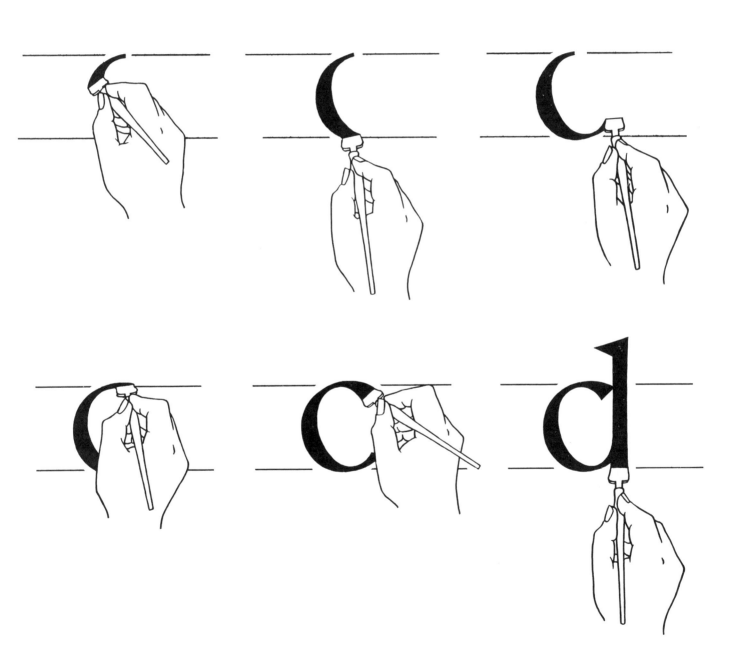

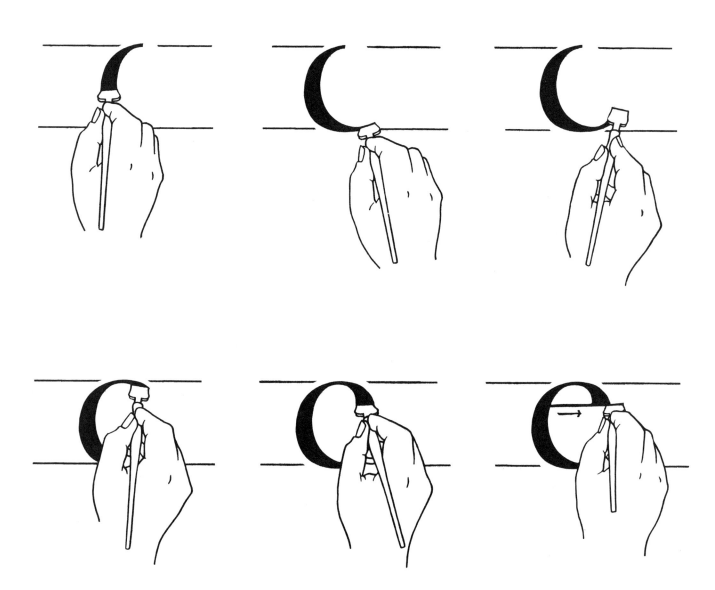

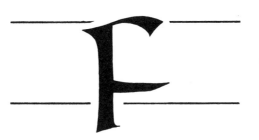

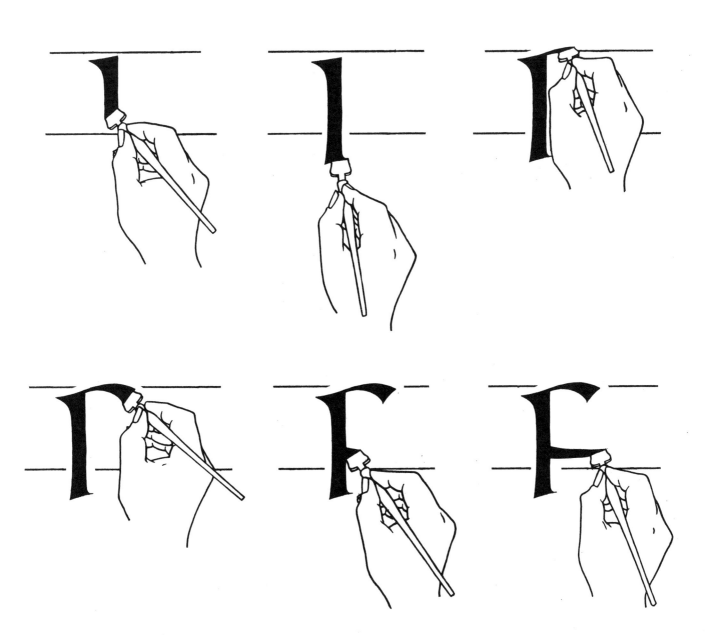

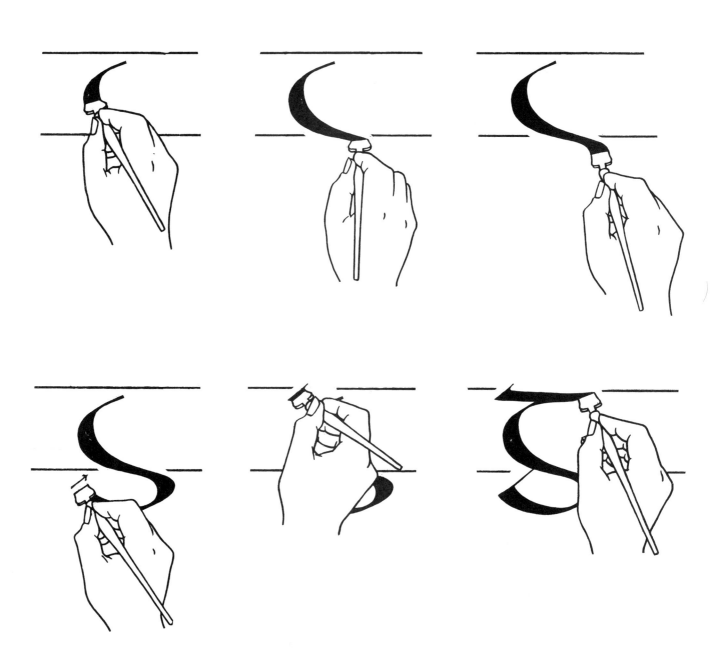

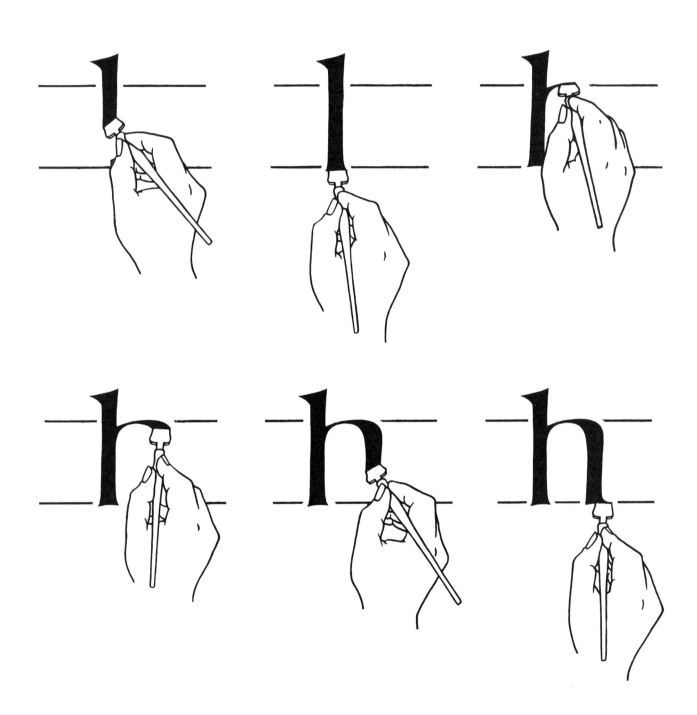

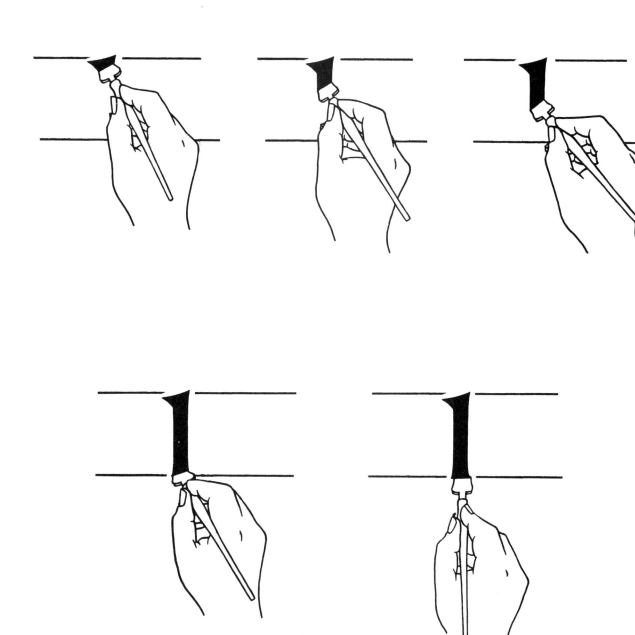

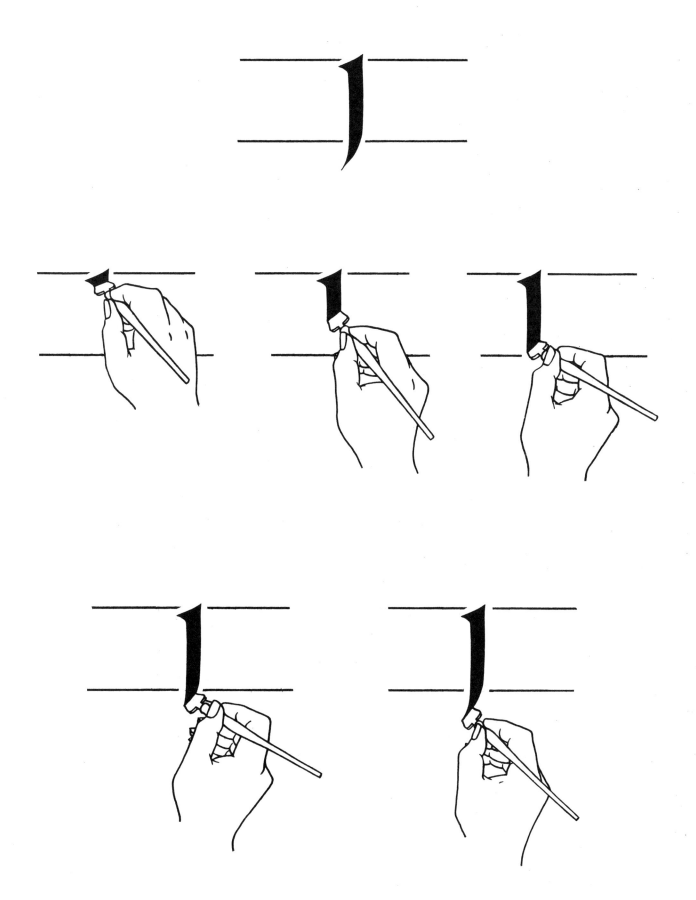

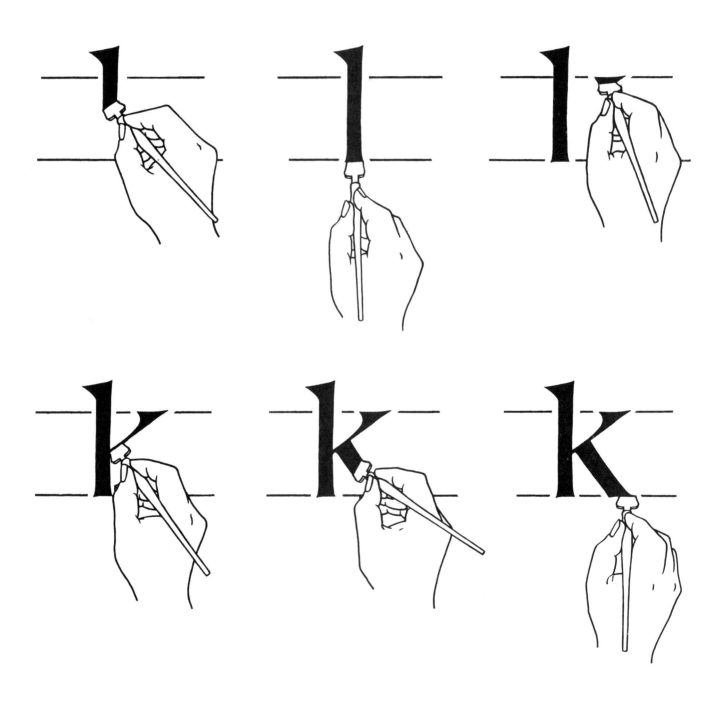

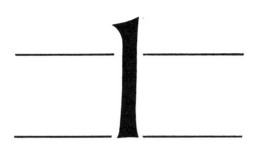

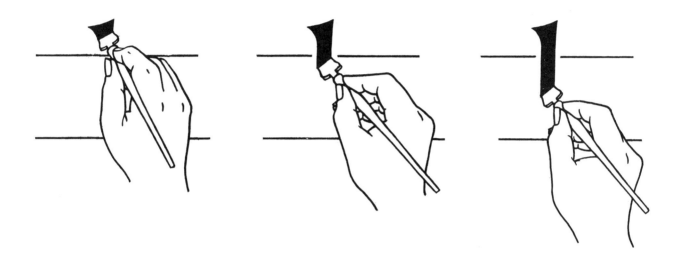

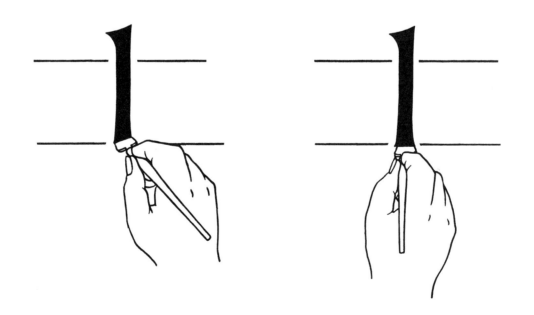

m

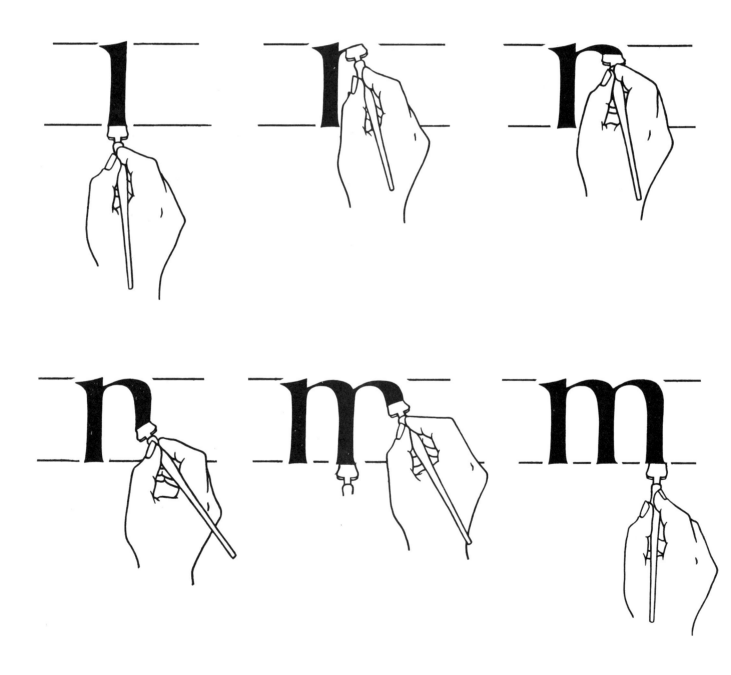

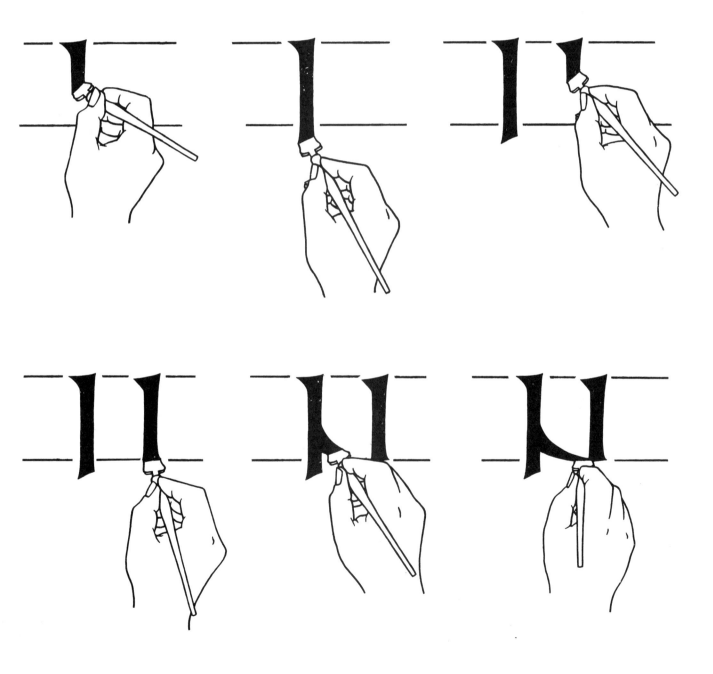

Alternate form of letter *n*.

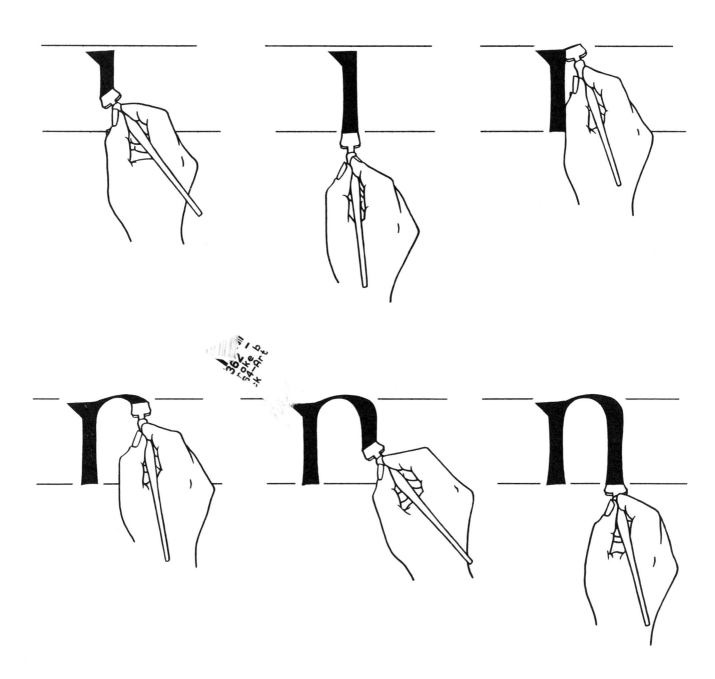

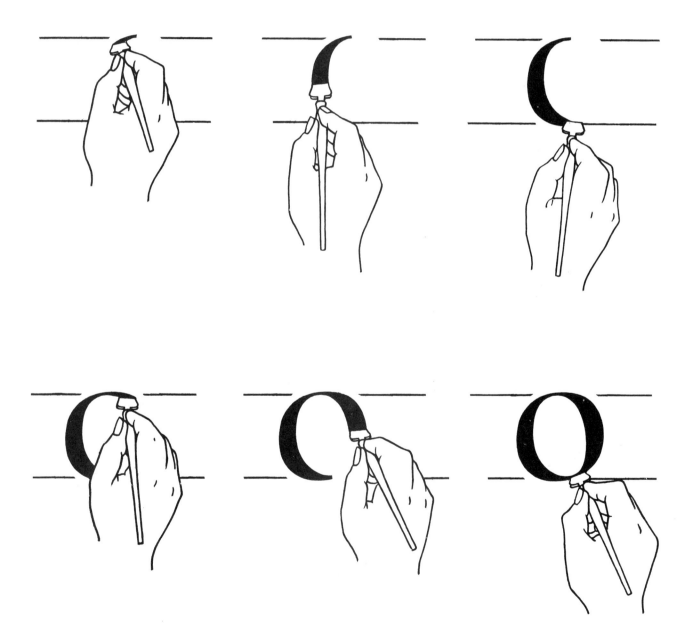

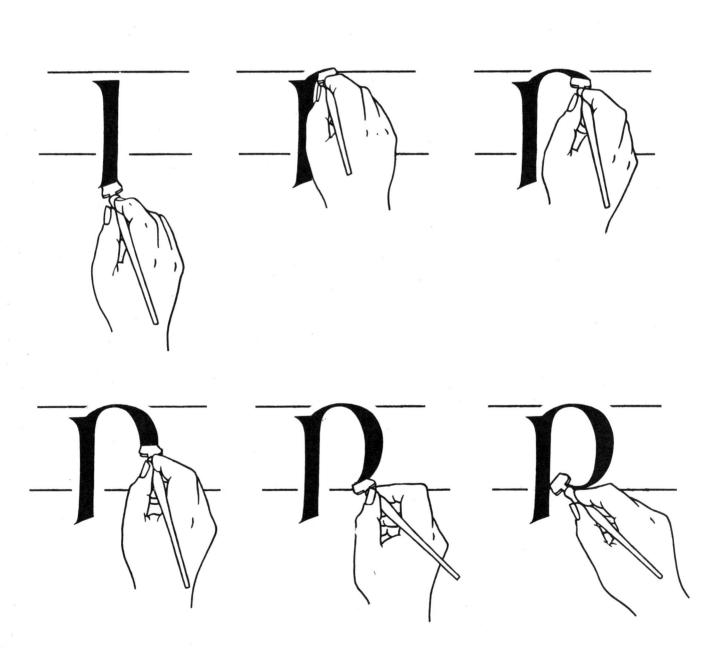

q

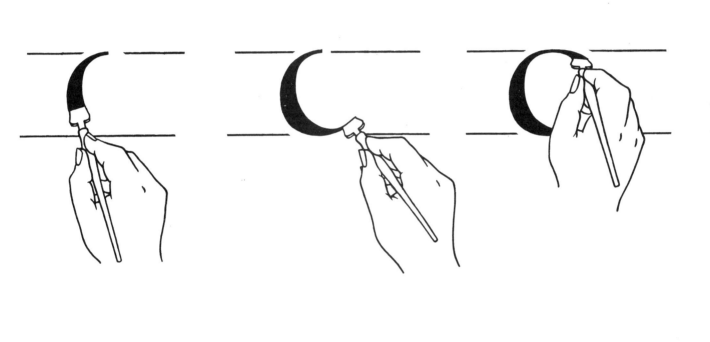

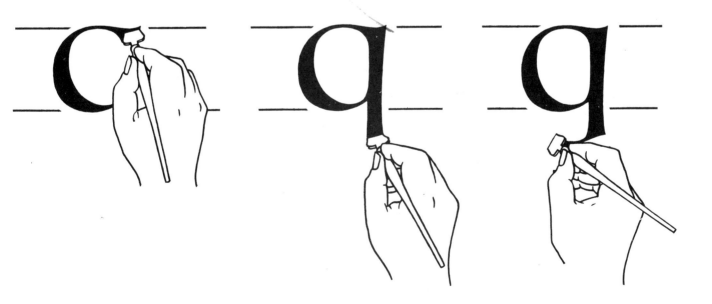

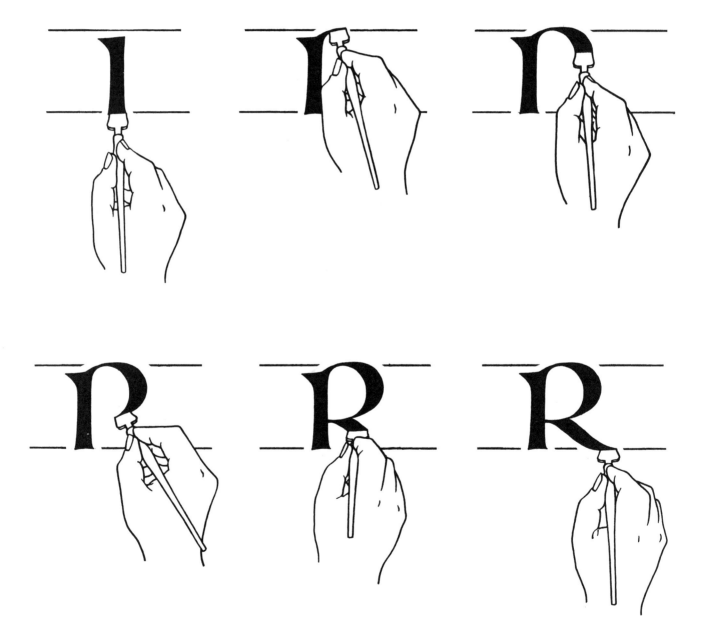

S

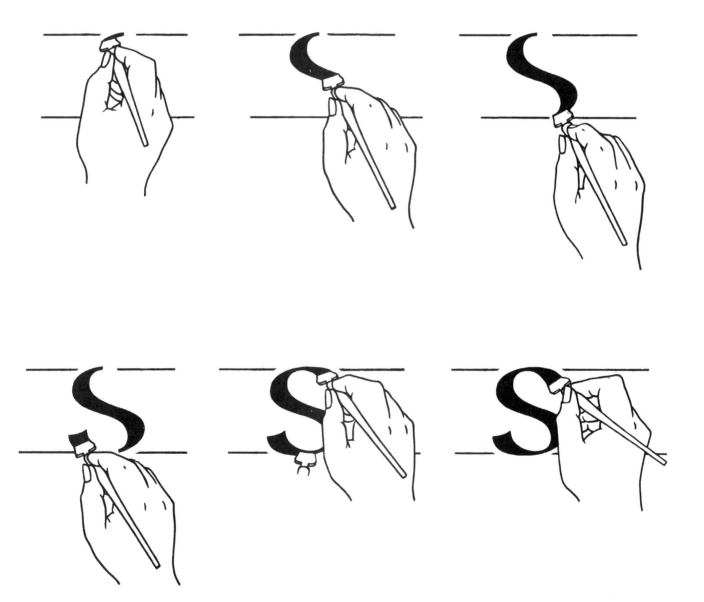

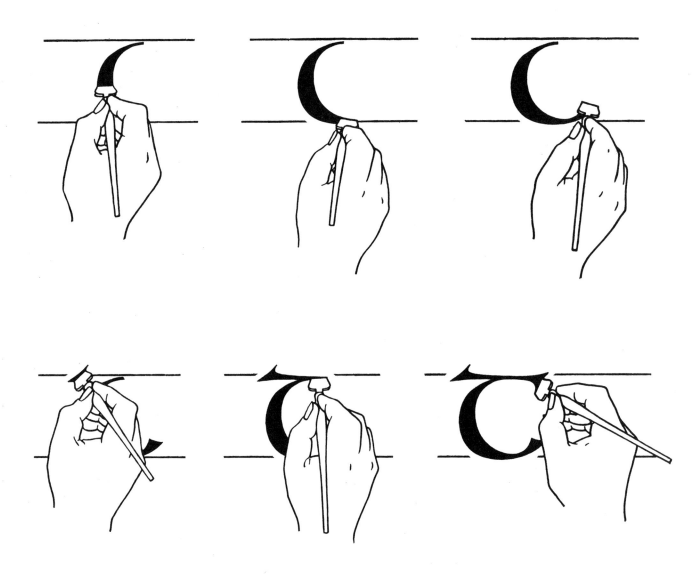

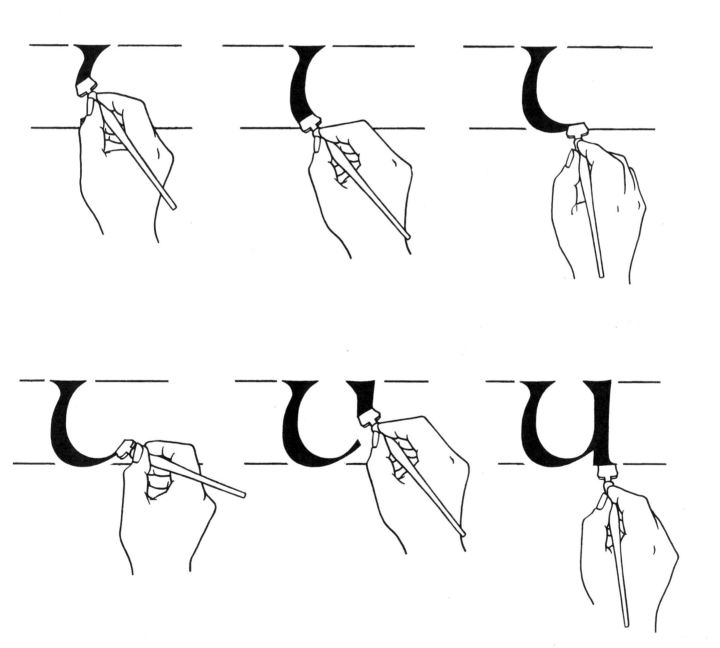

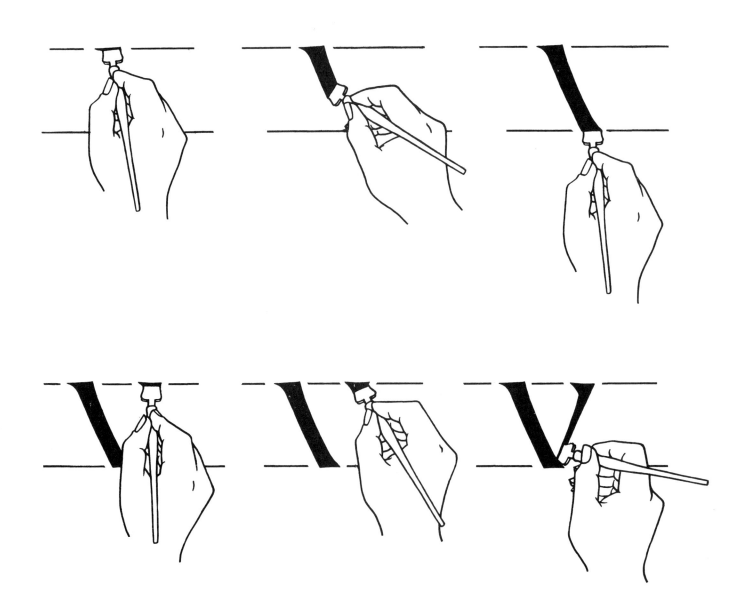

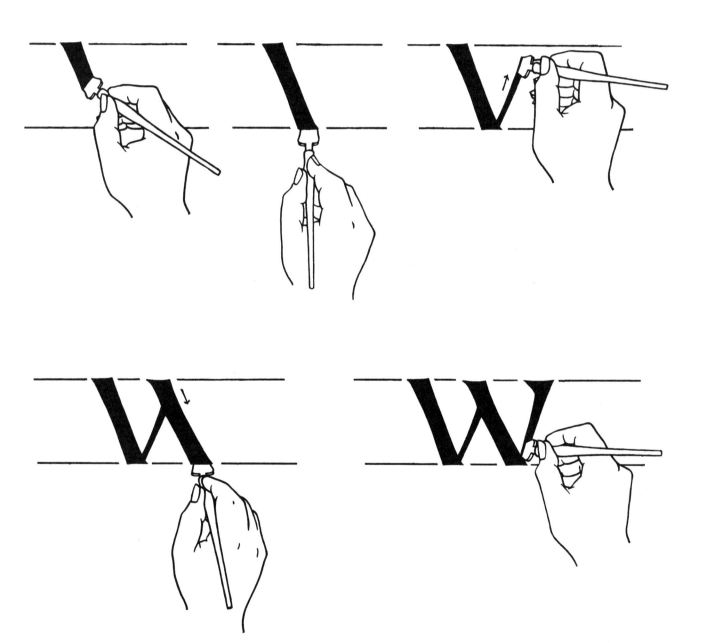

43

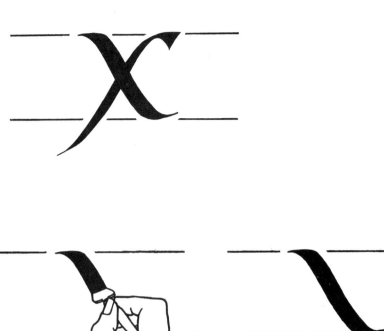

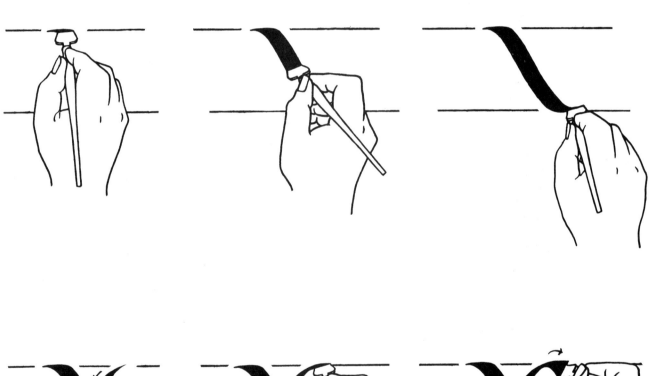

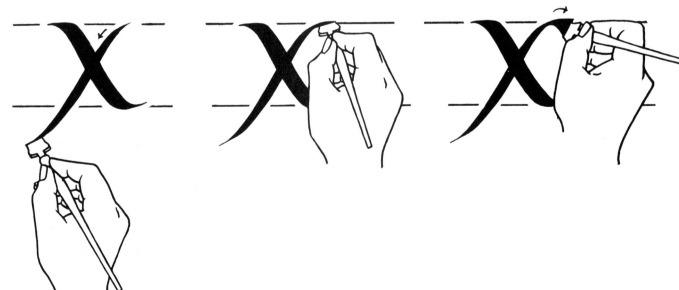

y

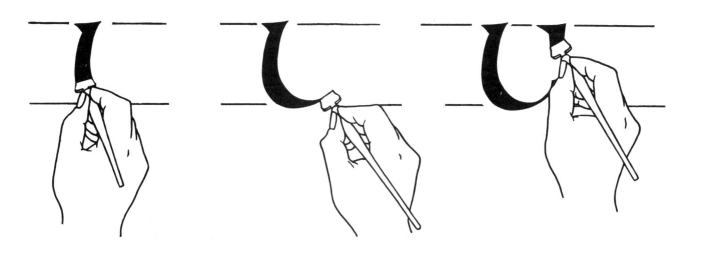

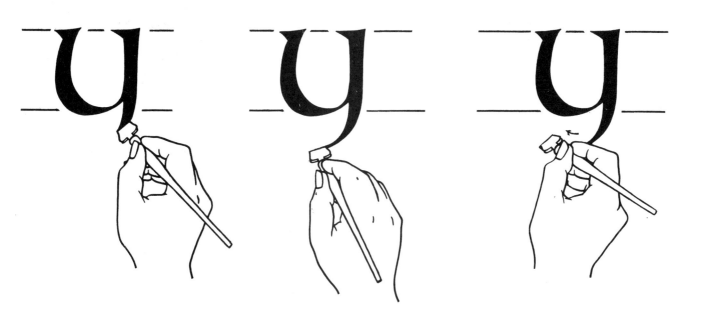

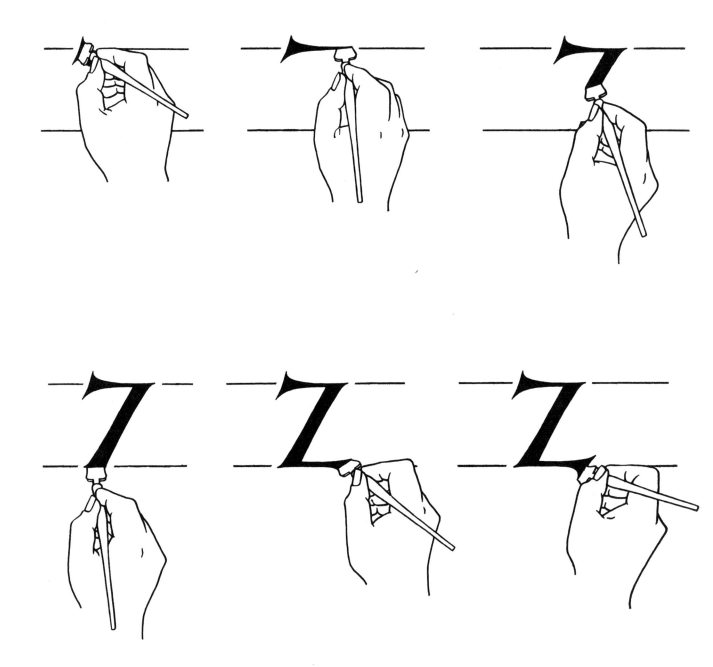